WOODCUT DESIGNS

COLORING BOOK

Diverse Designs on a Dramatic Black Background

TIM FOLEY

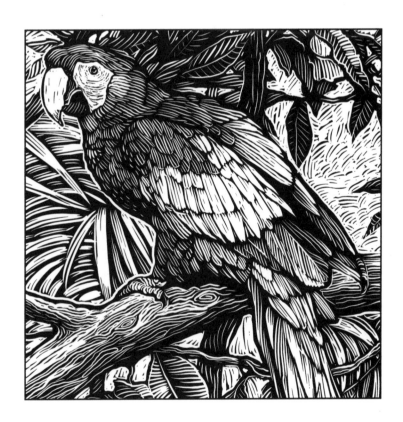

DOVER PUBLICATIONS, INC.
MINEOLA, NEW YORK

Exquisitely rendered in the classic style of woodcut illustrations, these striking line drawings are sure to pique your coloring creativity. This collection of thirty-one plates offers an imaginative mix of subjects, including florals, jungle animals, landscapes, and sporting events. These gloriously detailed and dynamic designs are intended especially for the experienced colorist. The pages in this book are unbacked so that you may use any media for coloring, and are perforated for easy removal.

Copyright

Copyright © 2016 by Dover Publications, Inc.
All rights reserved.

Bibliographical Note

Woodcut Designs Coloring Book is a new work,
first published by Dover Publications, Inc., in 2016.

International Standard Book Number

ISBN-13: 978-0-486-80458-3
ISBN-10: 0-486-80458-5

Manufactured in the United States by RR Donnelley
80458504 2016
www.doverpublications.com

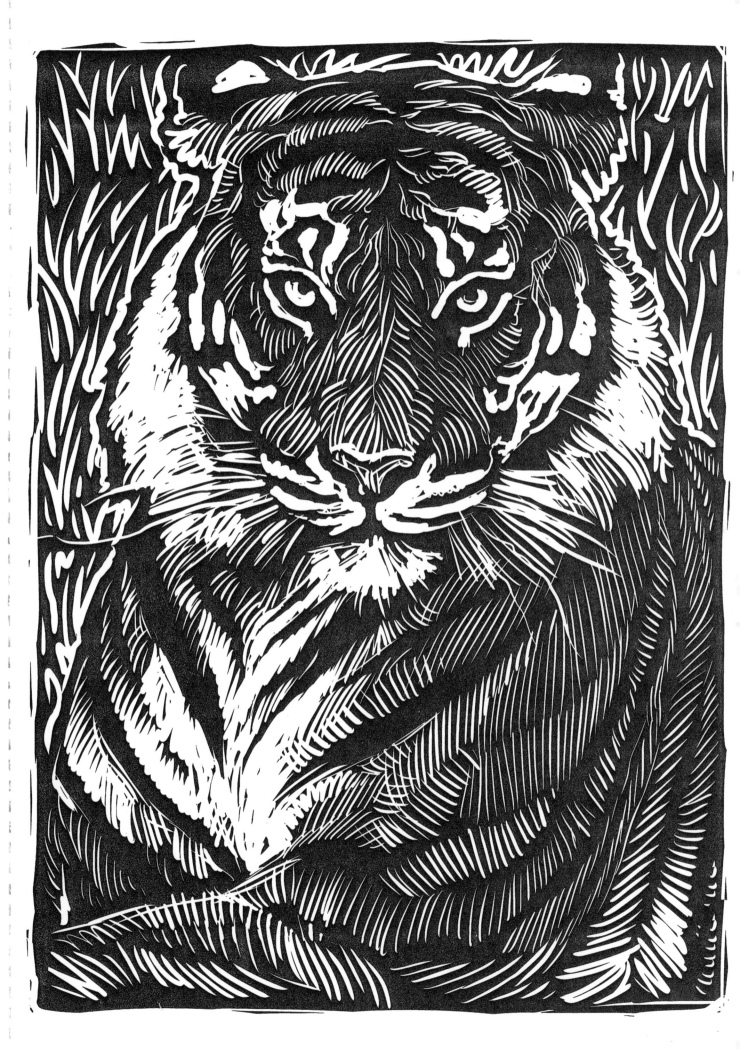

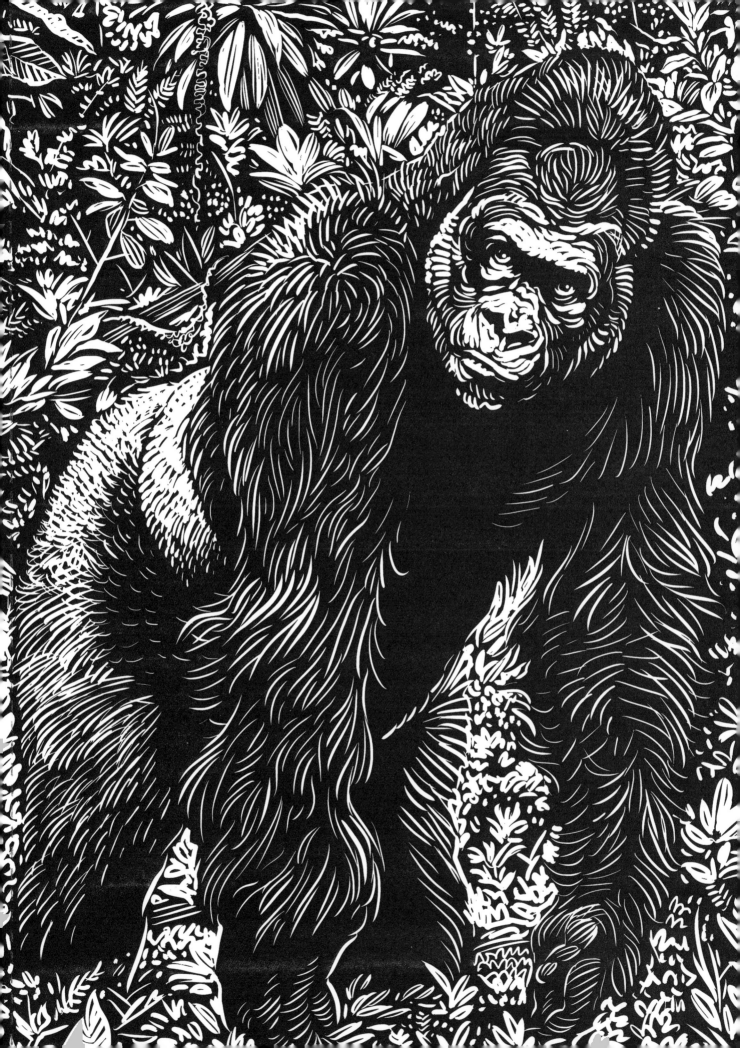

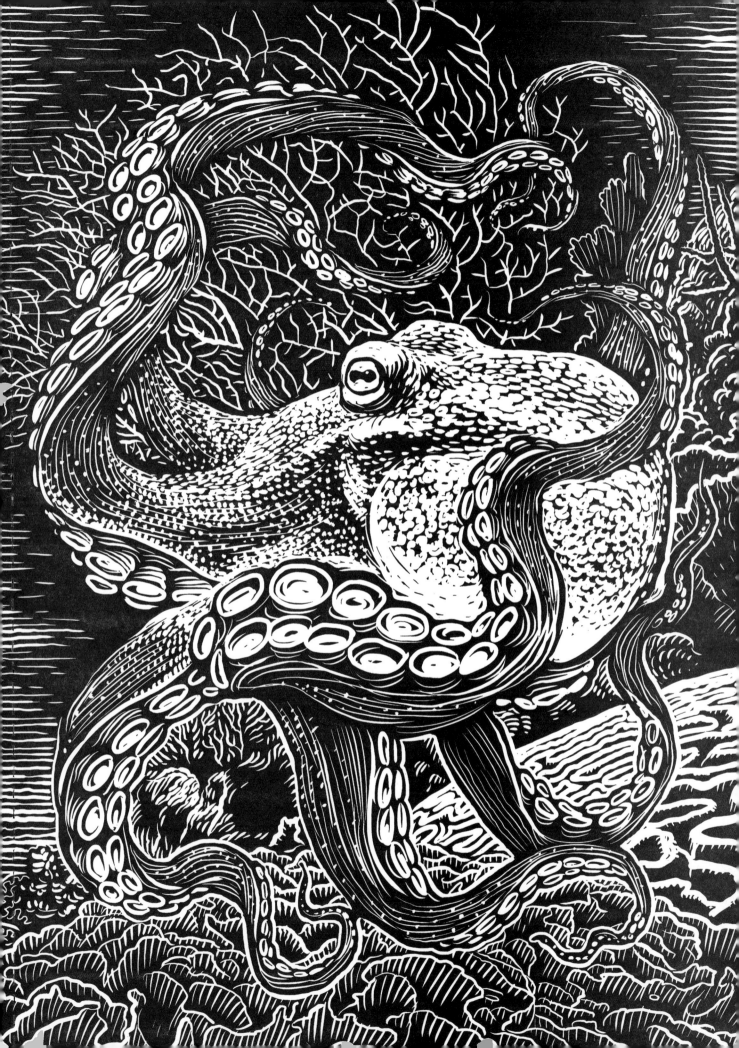

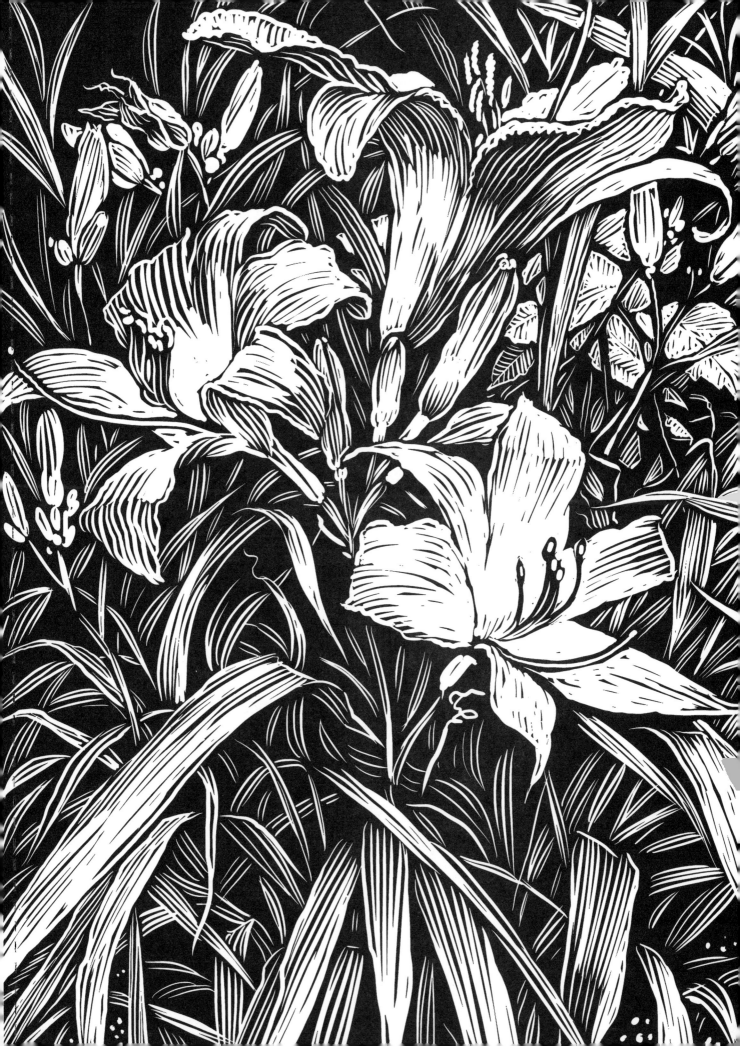

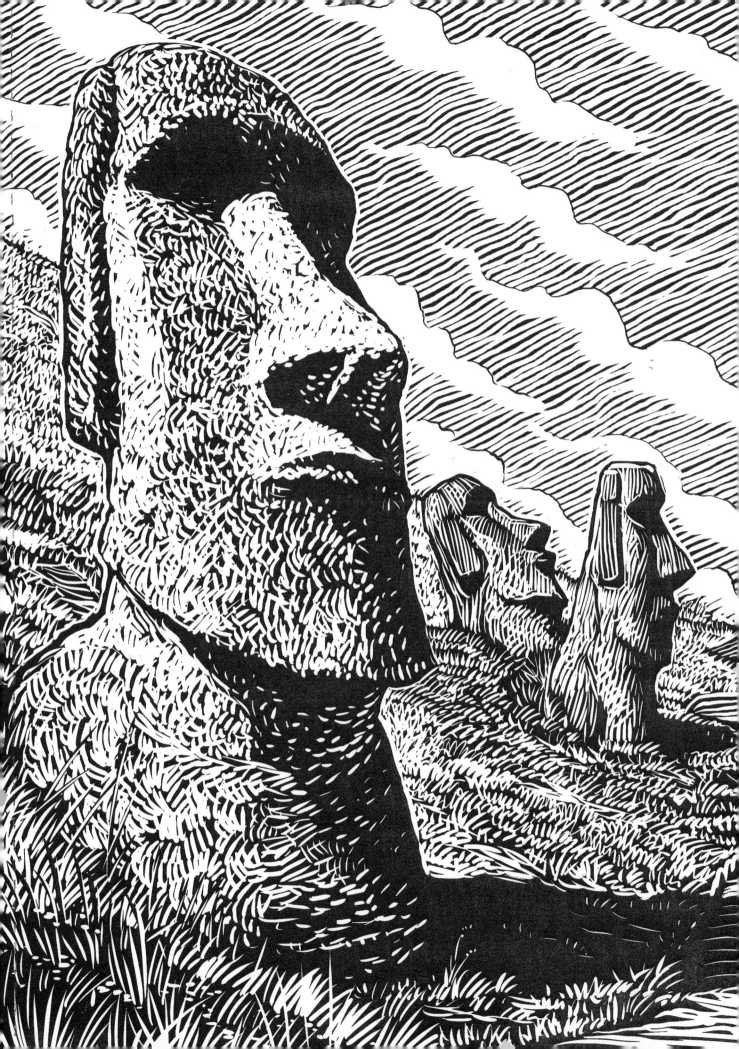

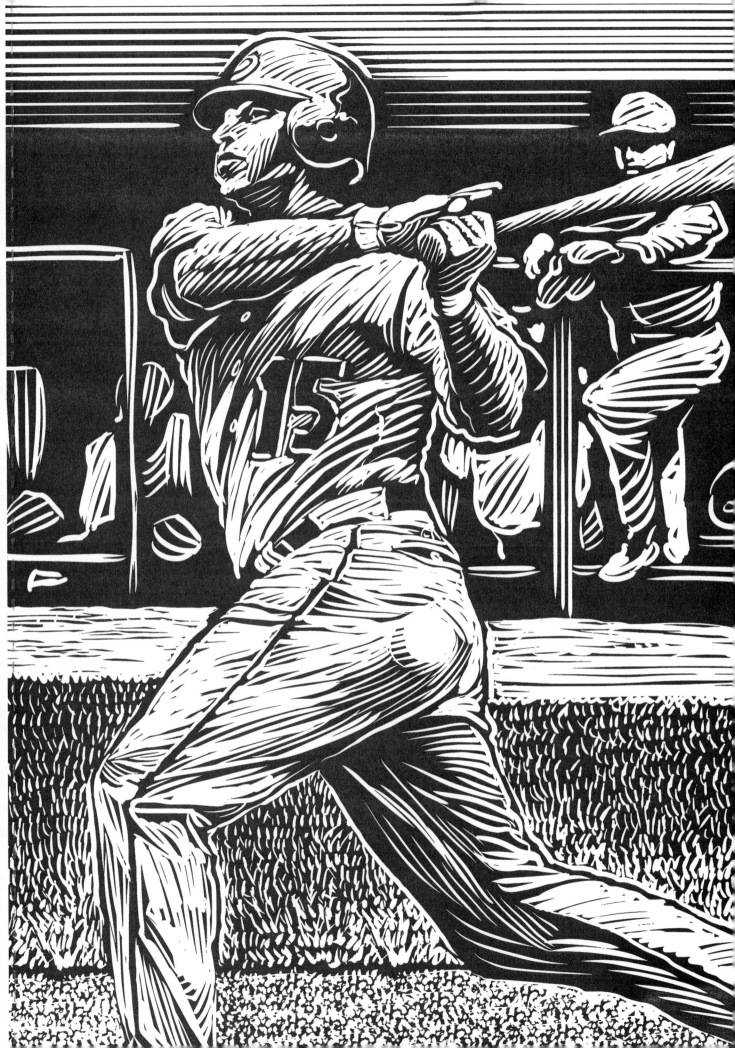

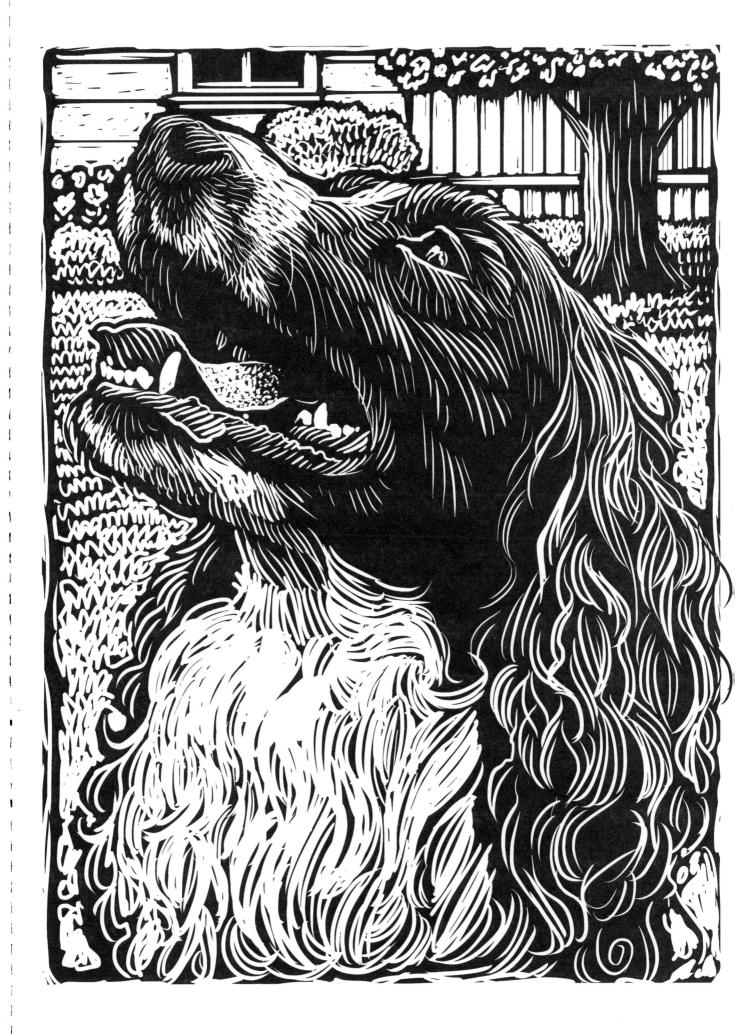

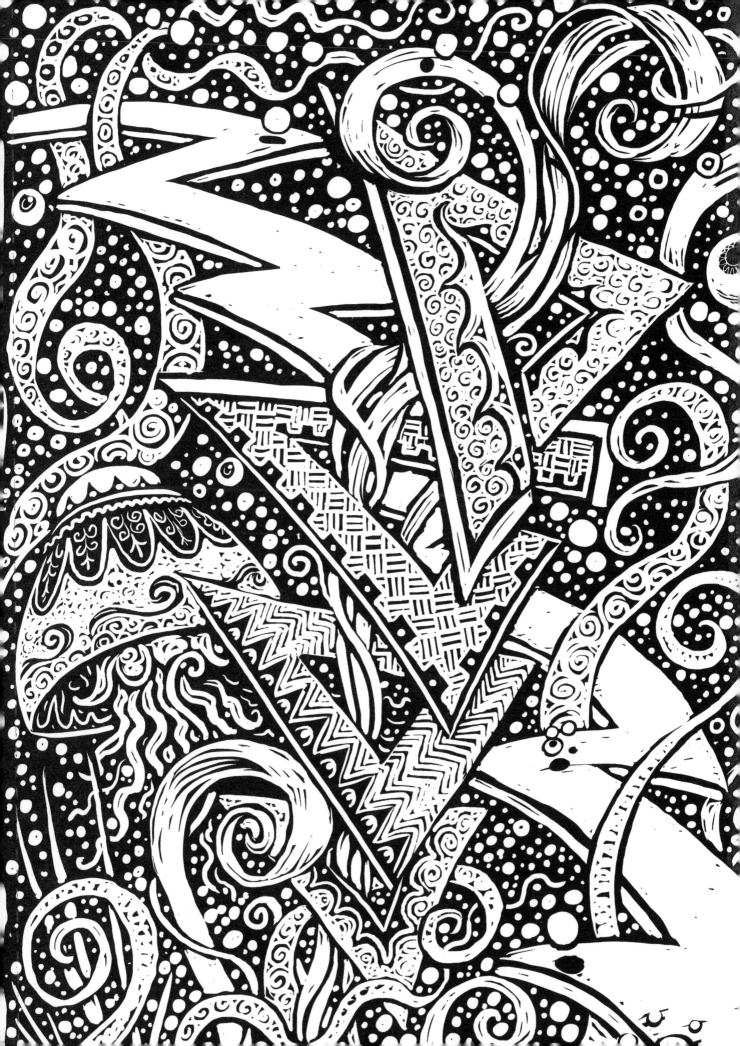

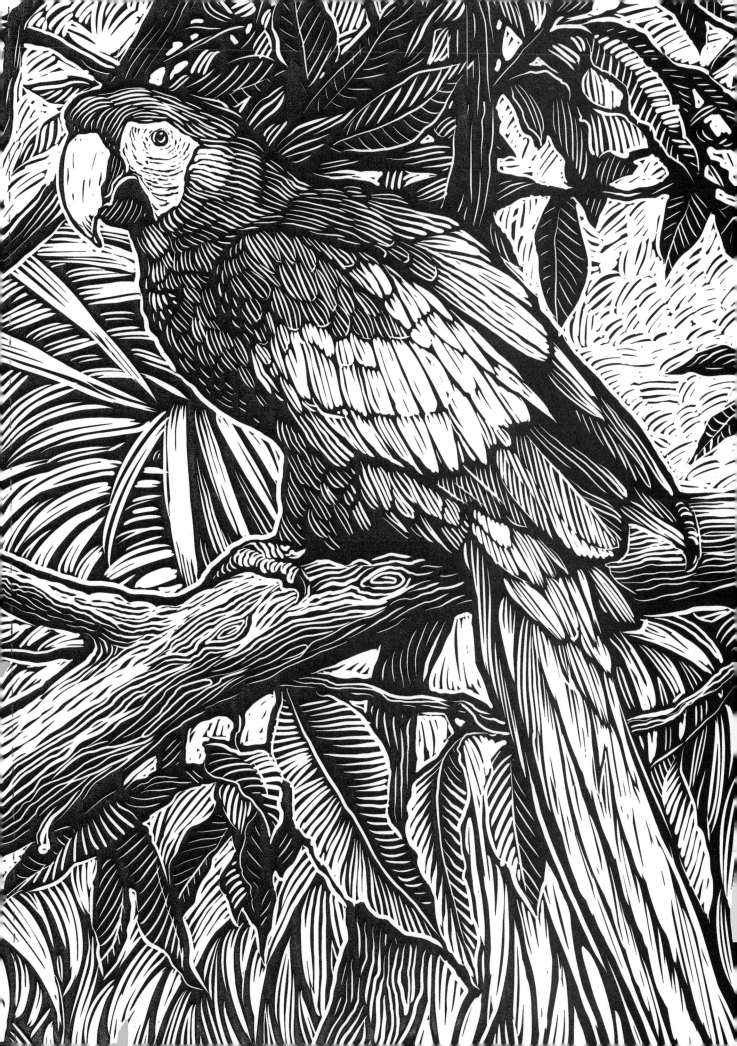

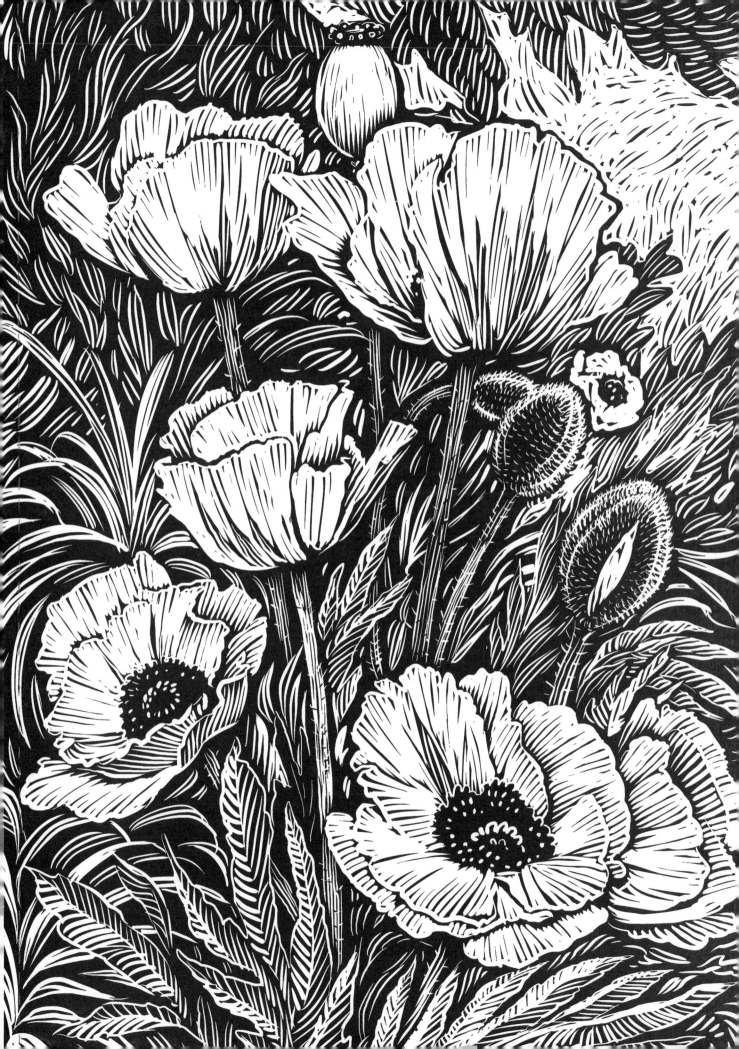

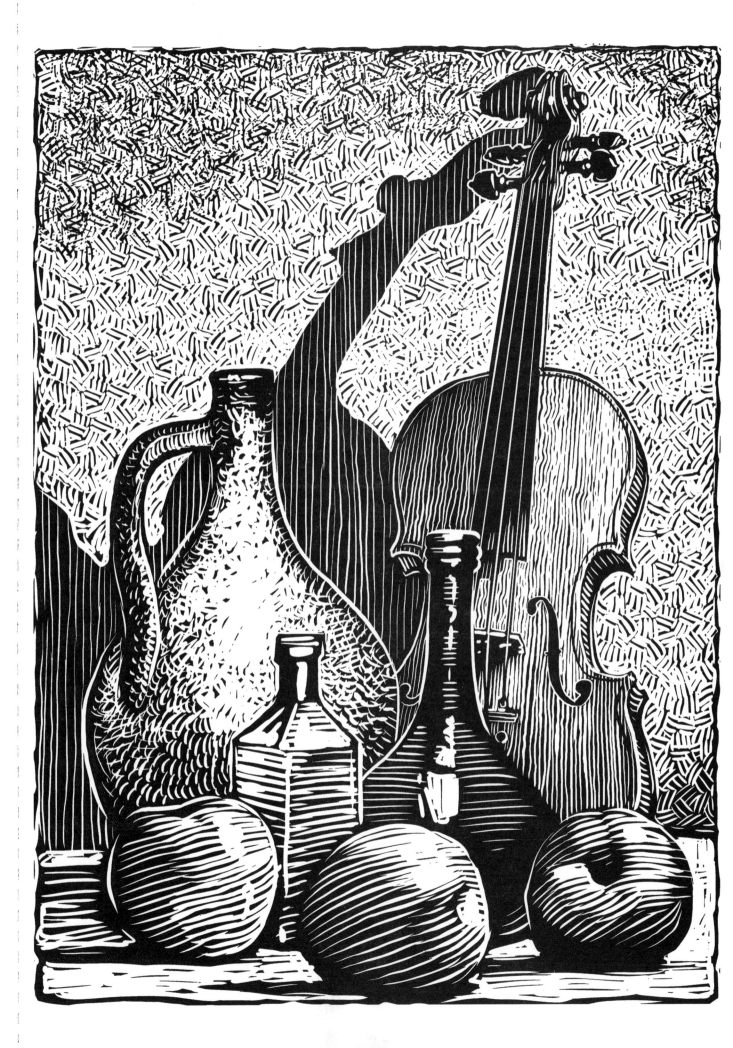

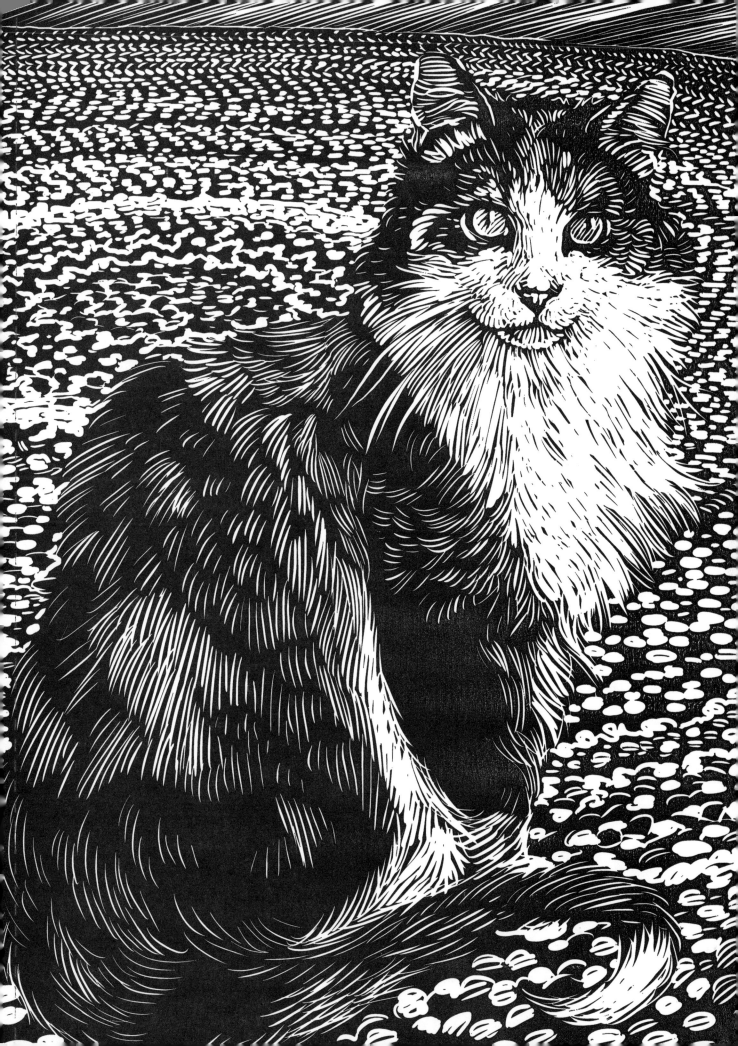

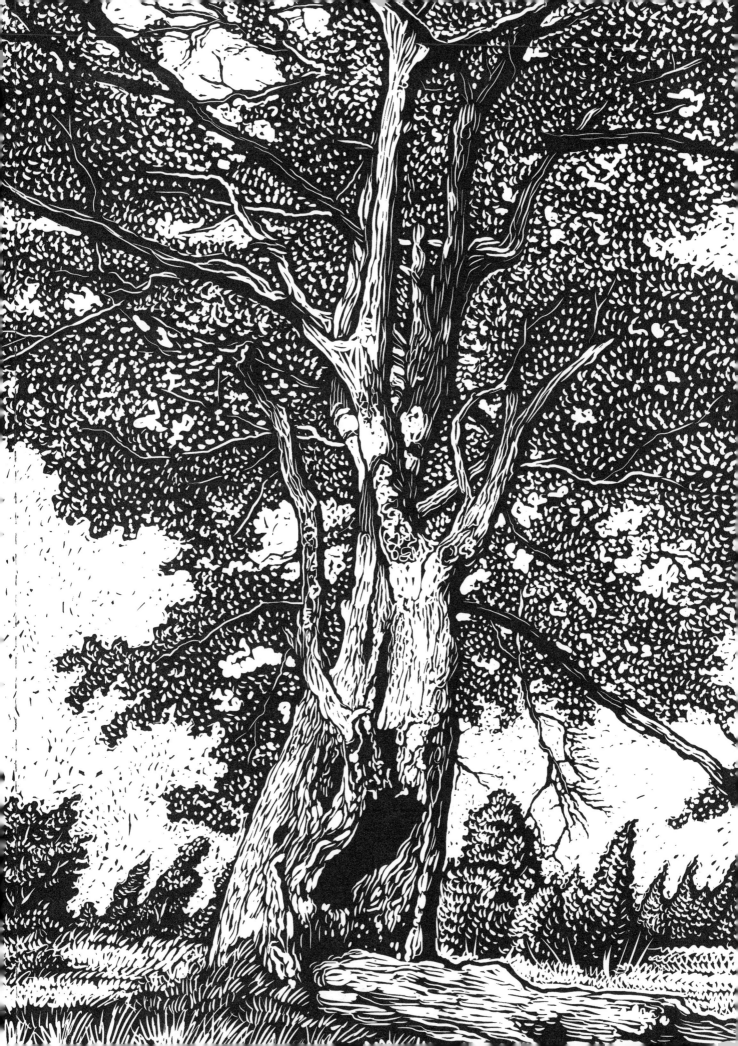

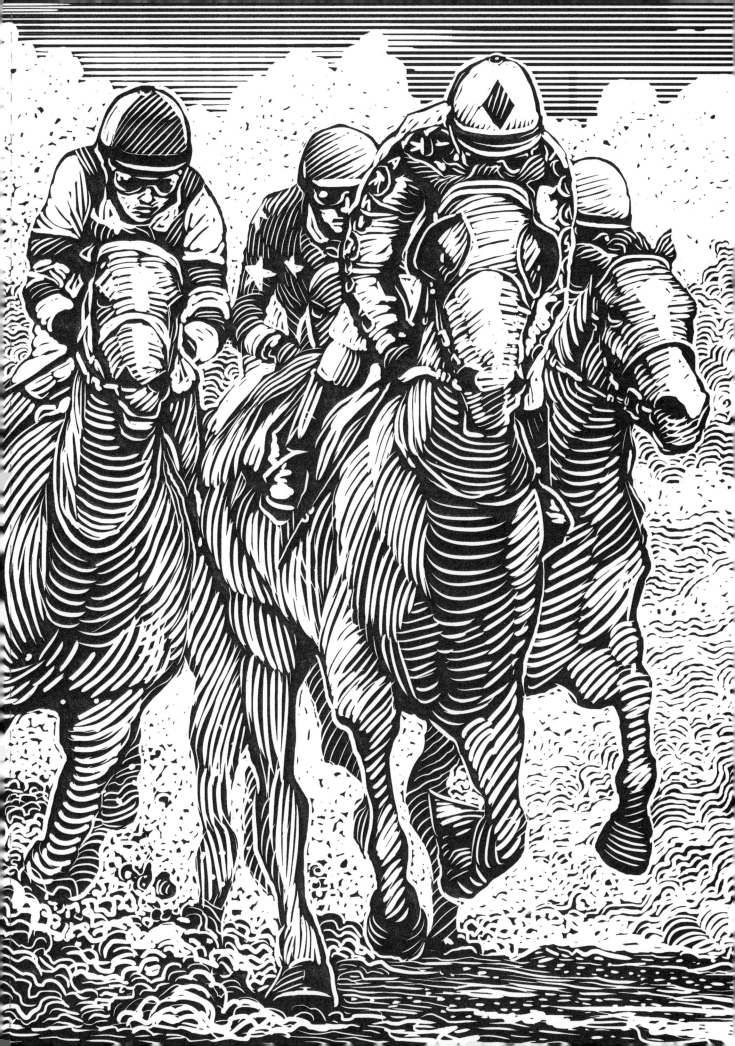

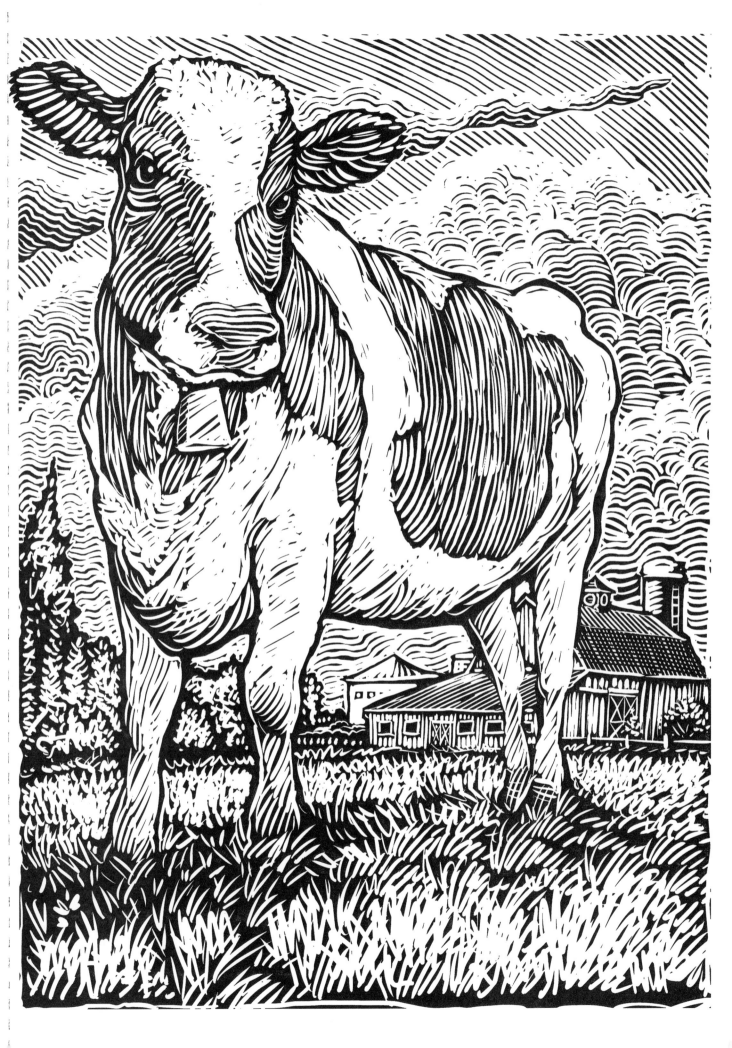

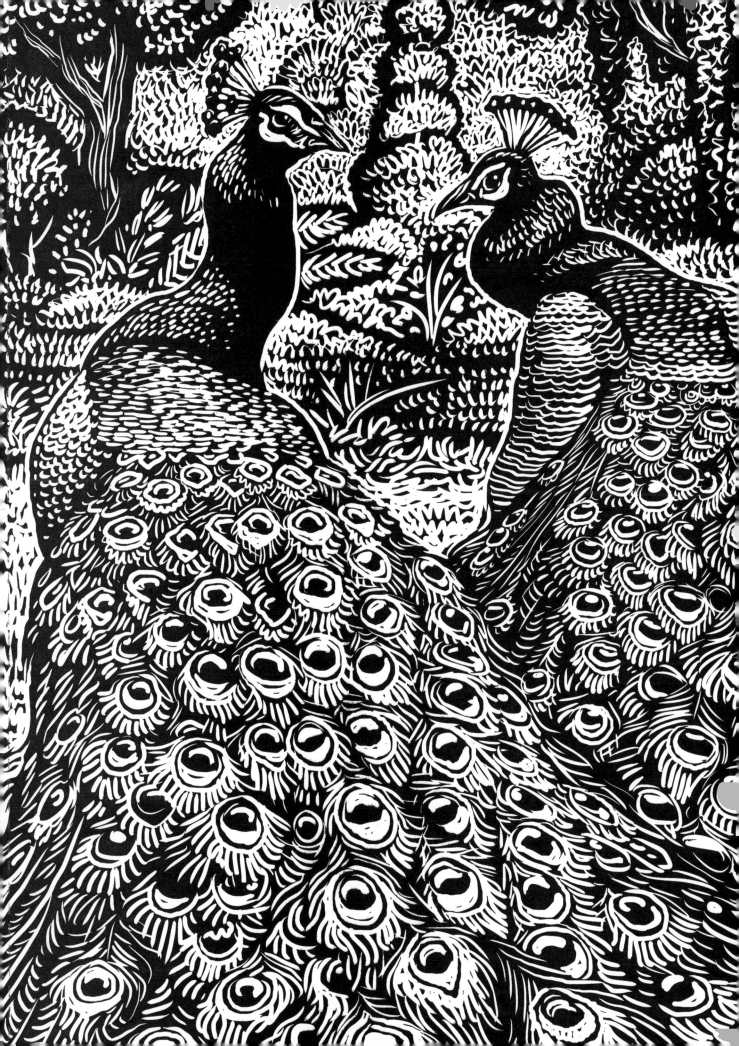

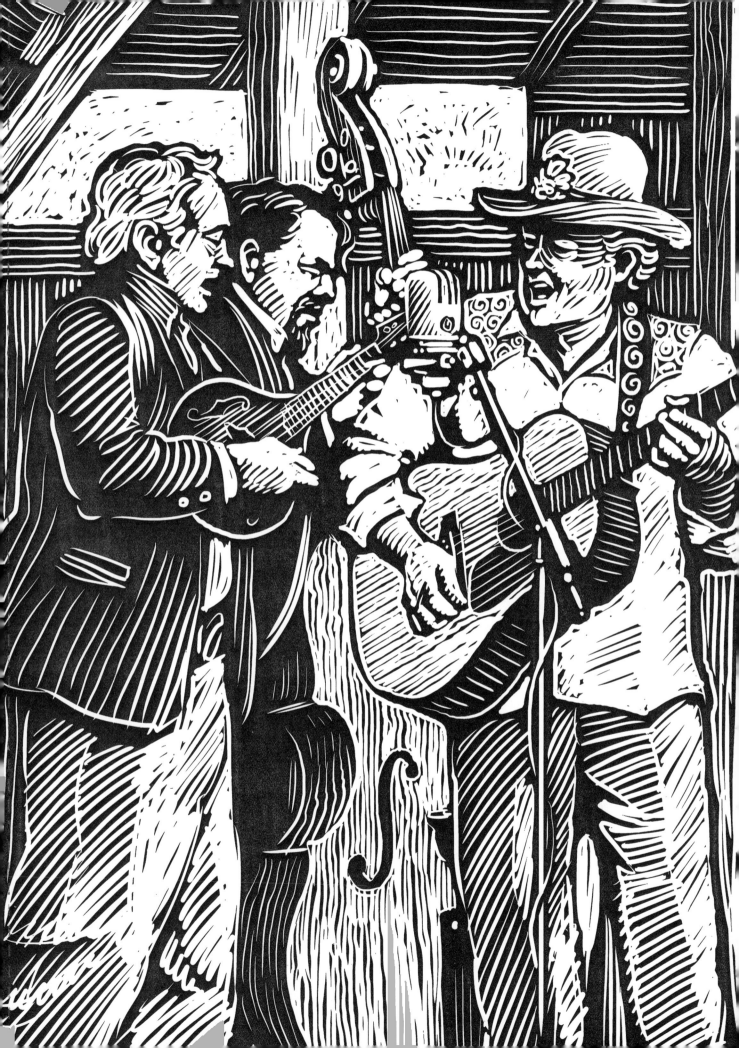

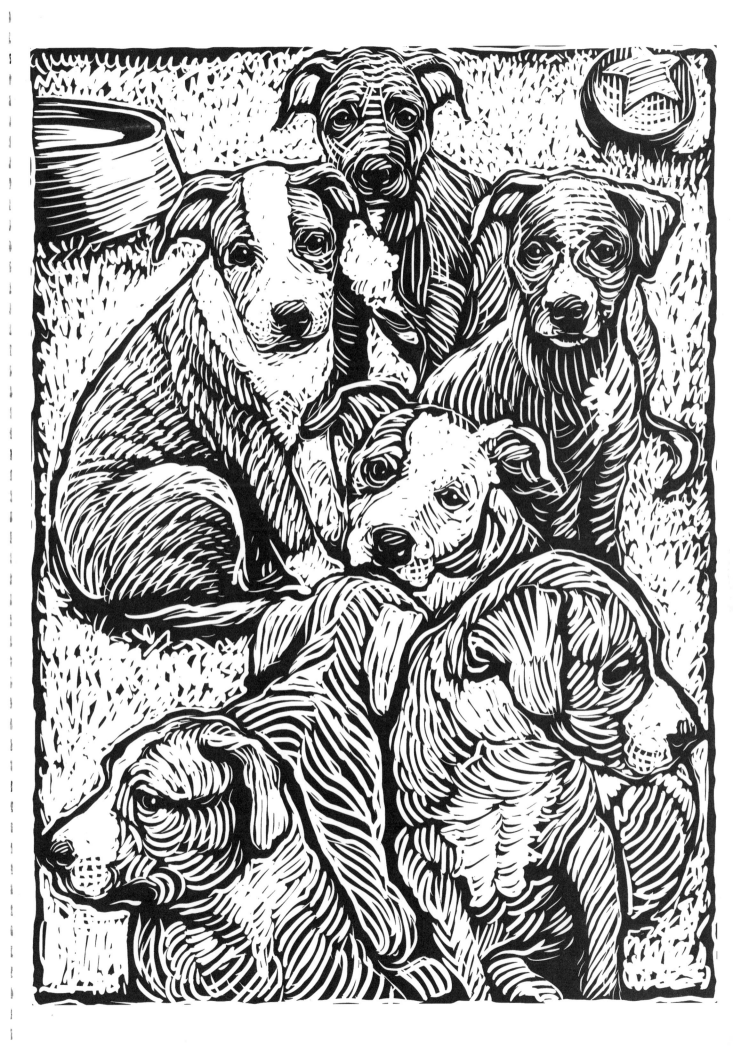

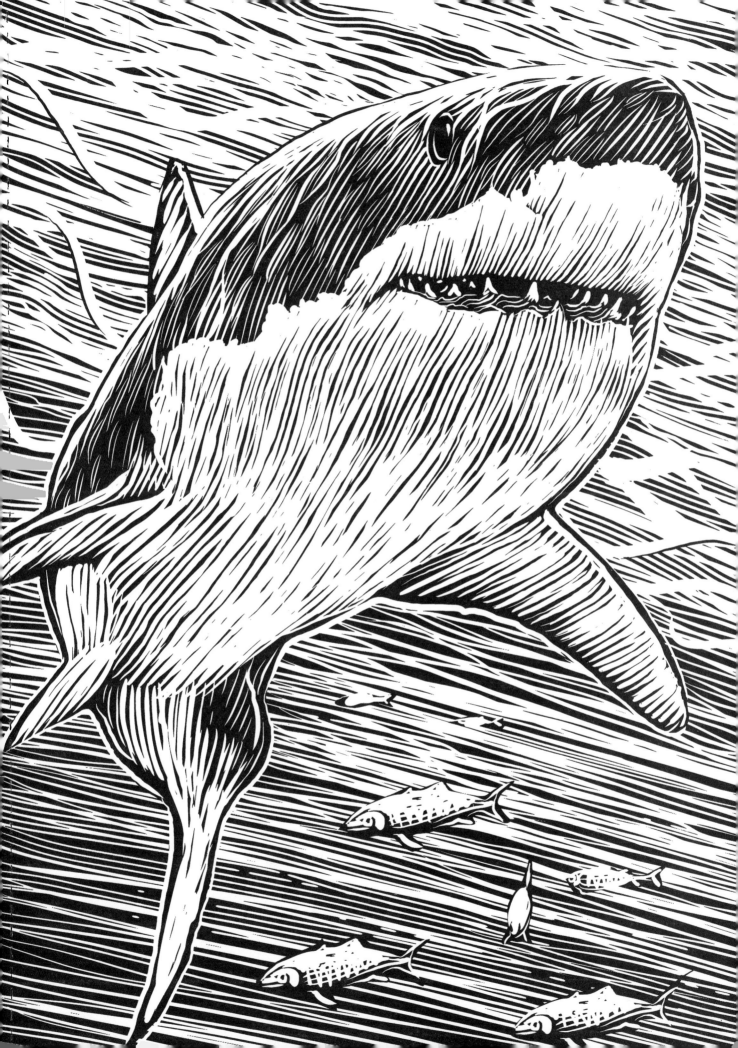

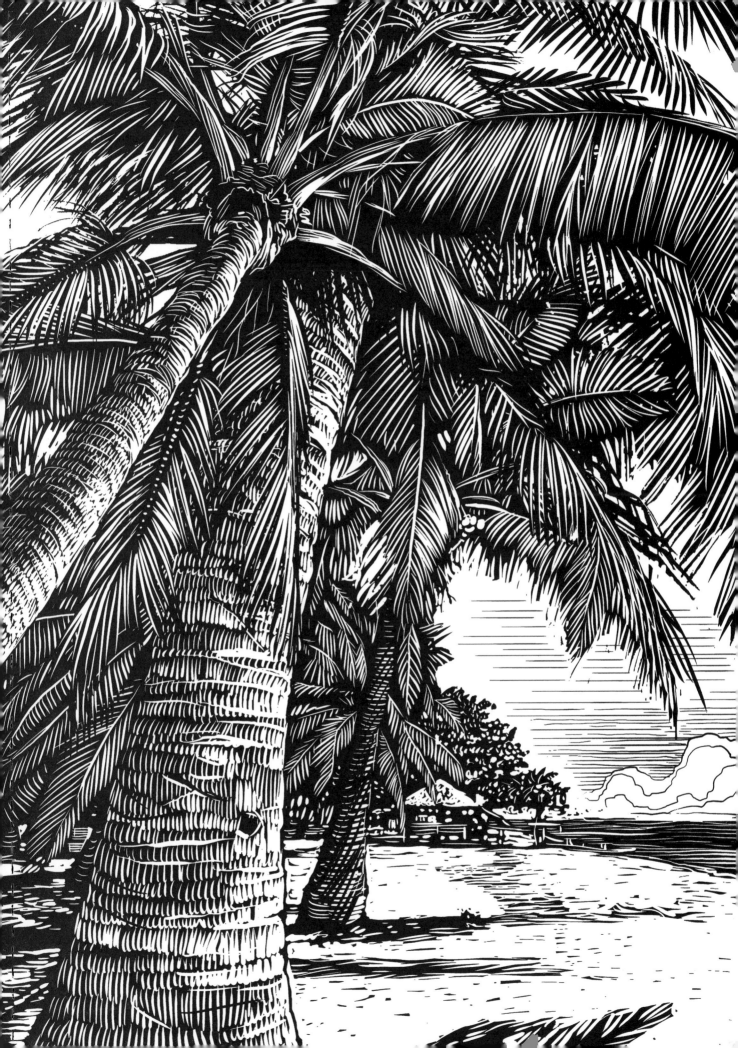

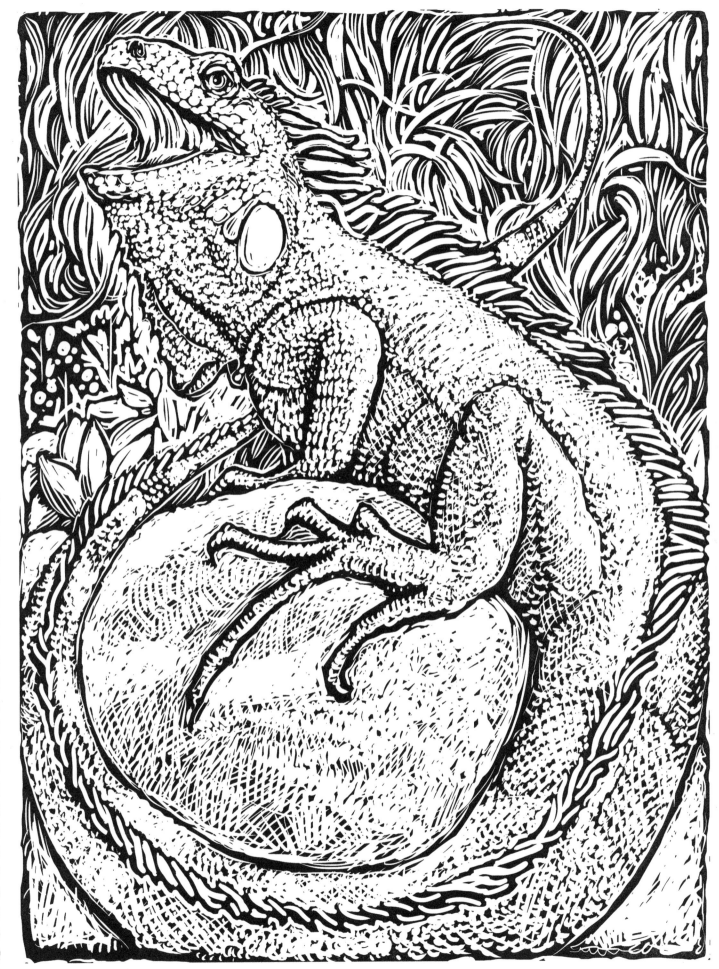

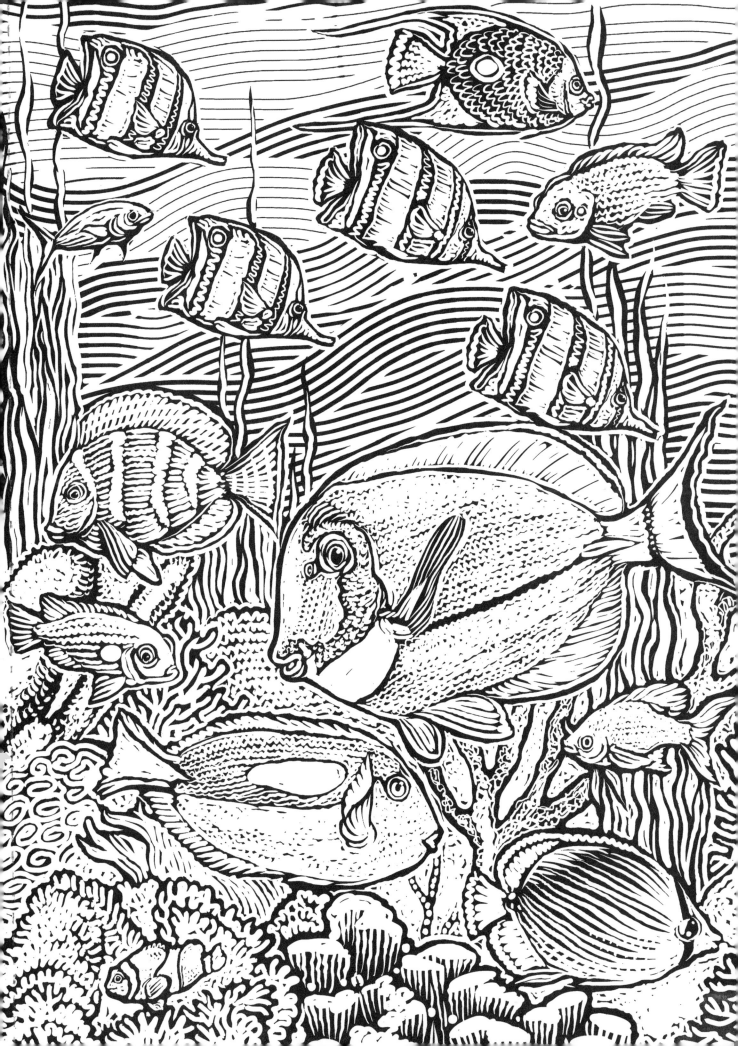

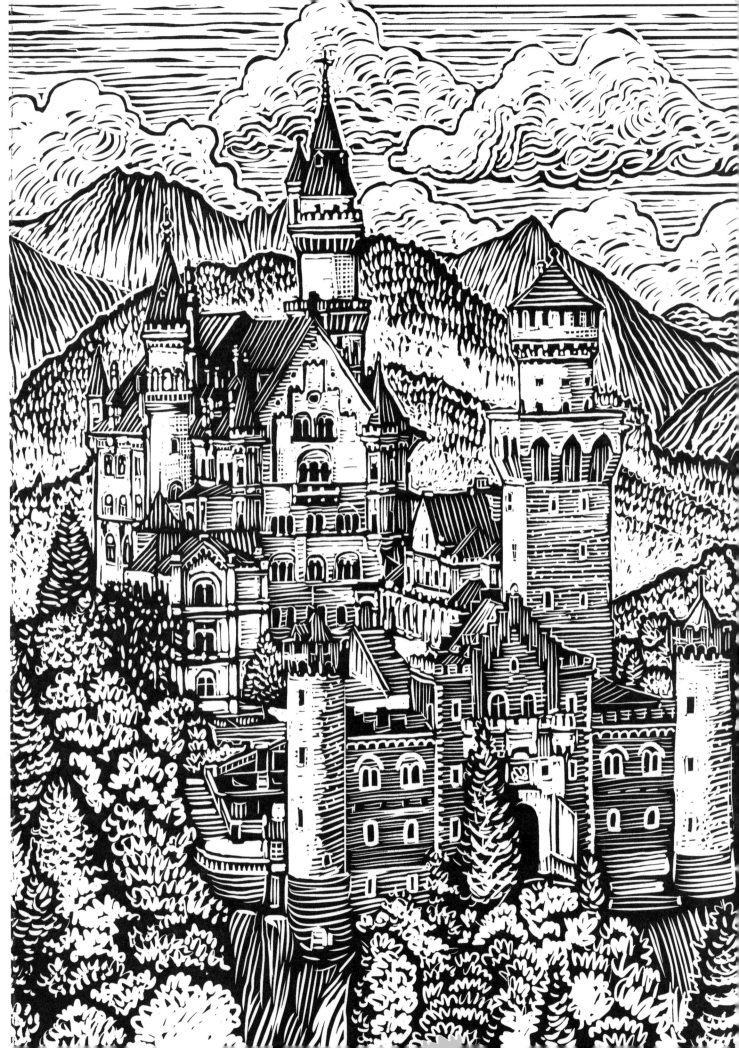

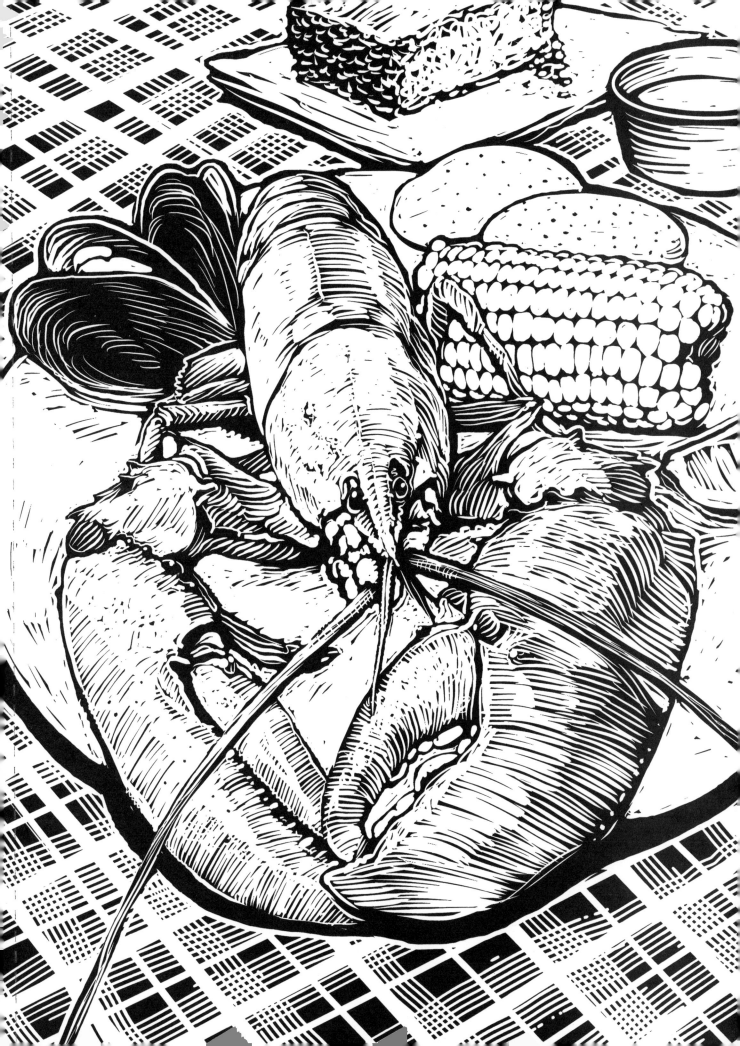

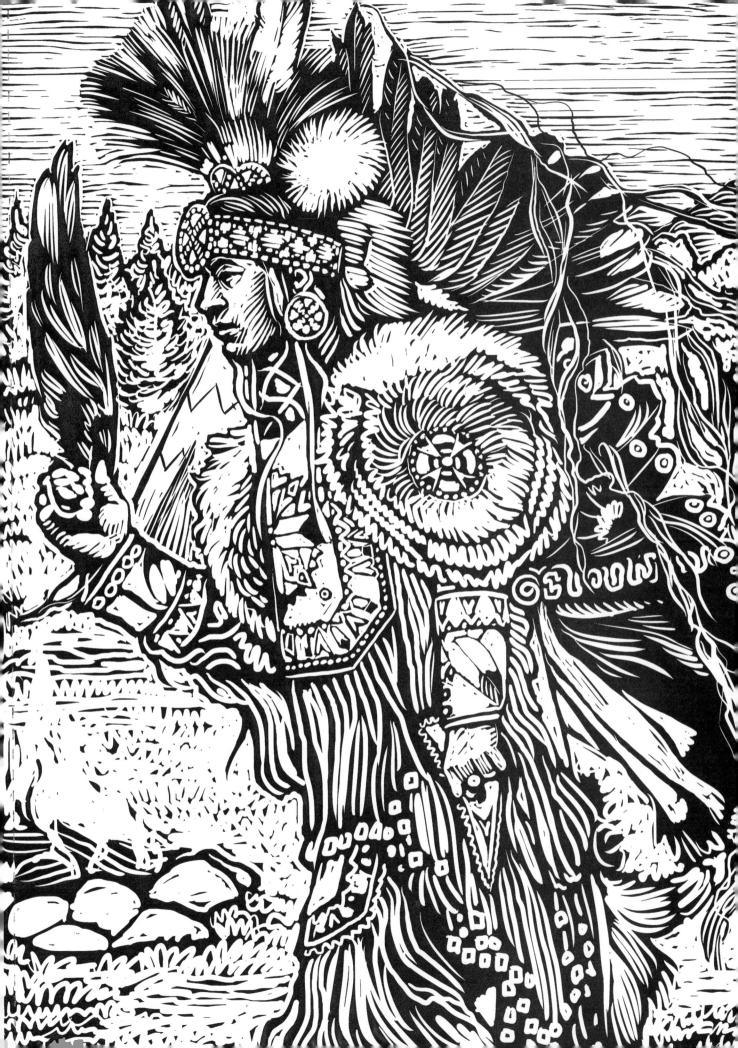

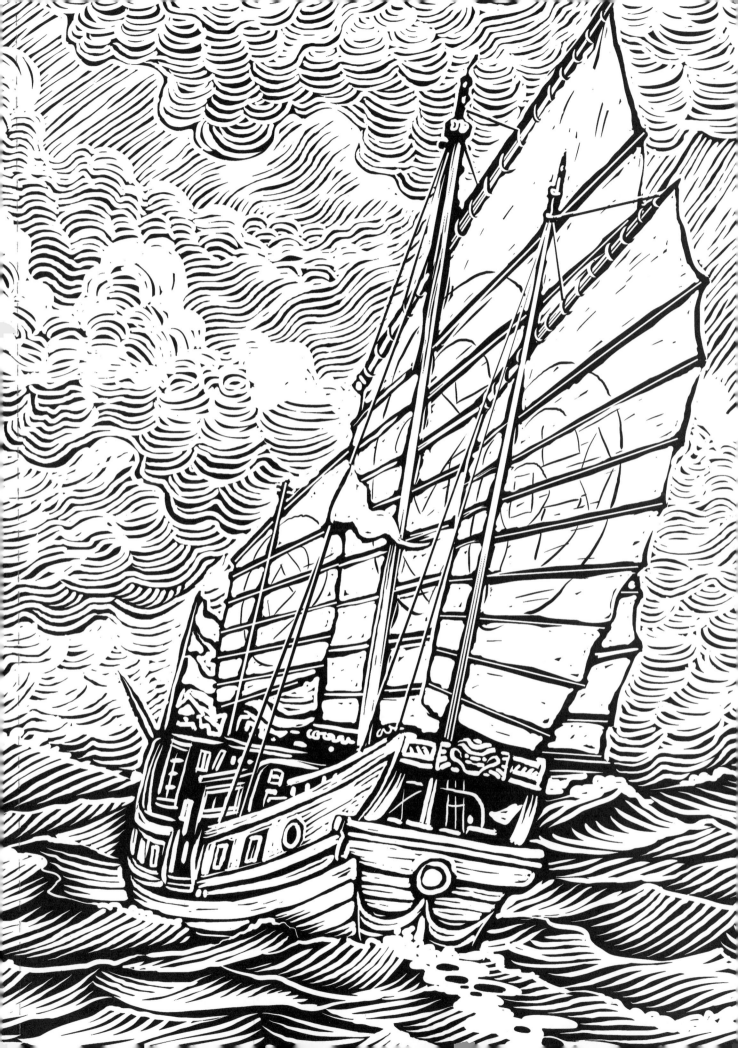

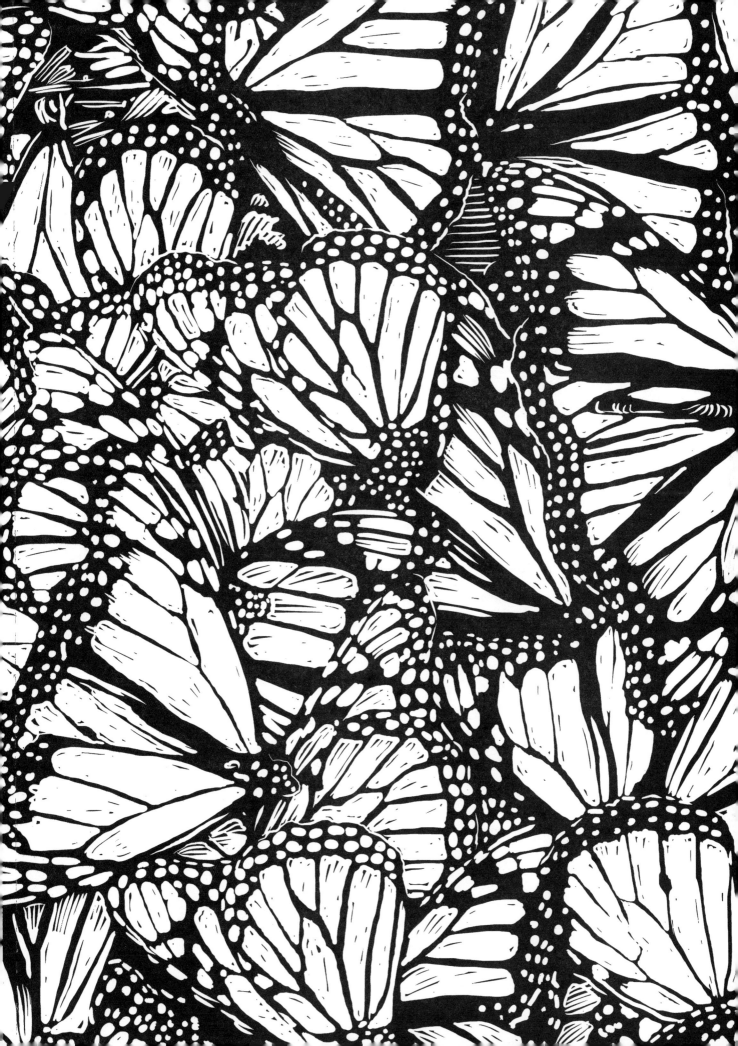

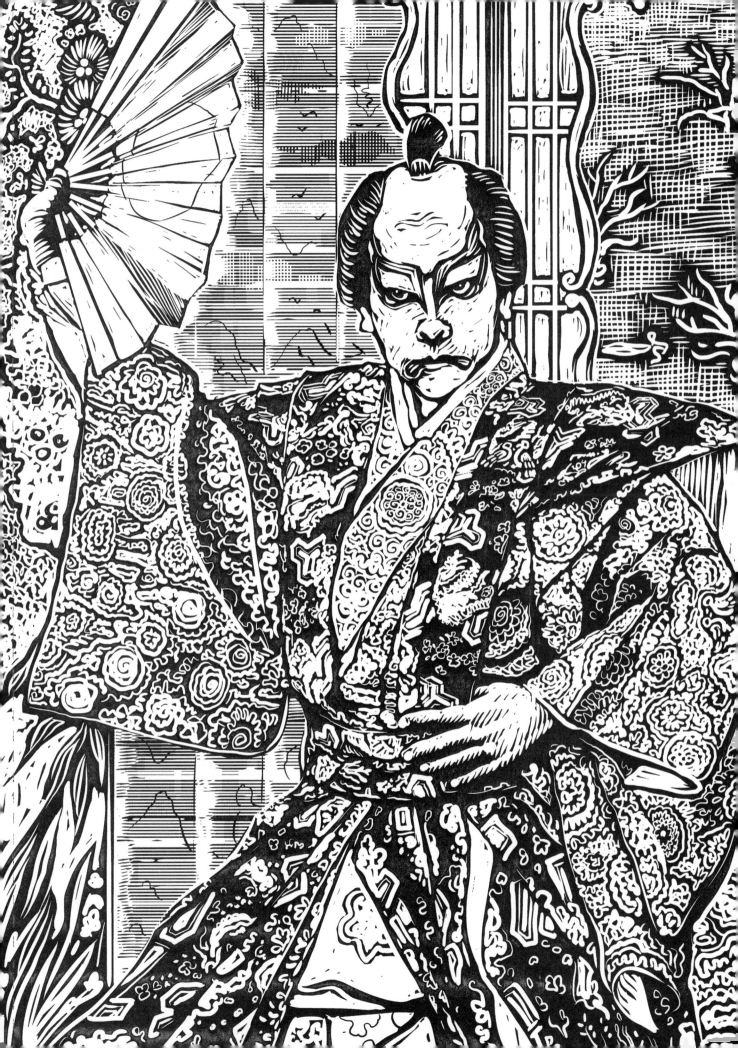

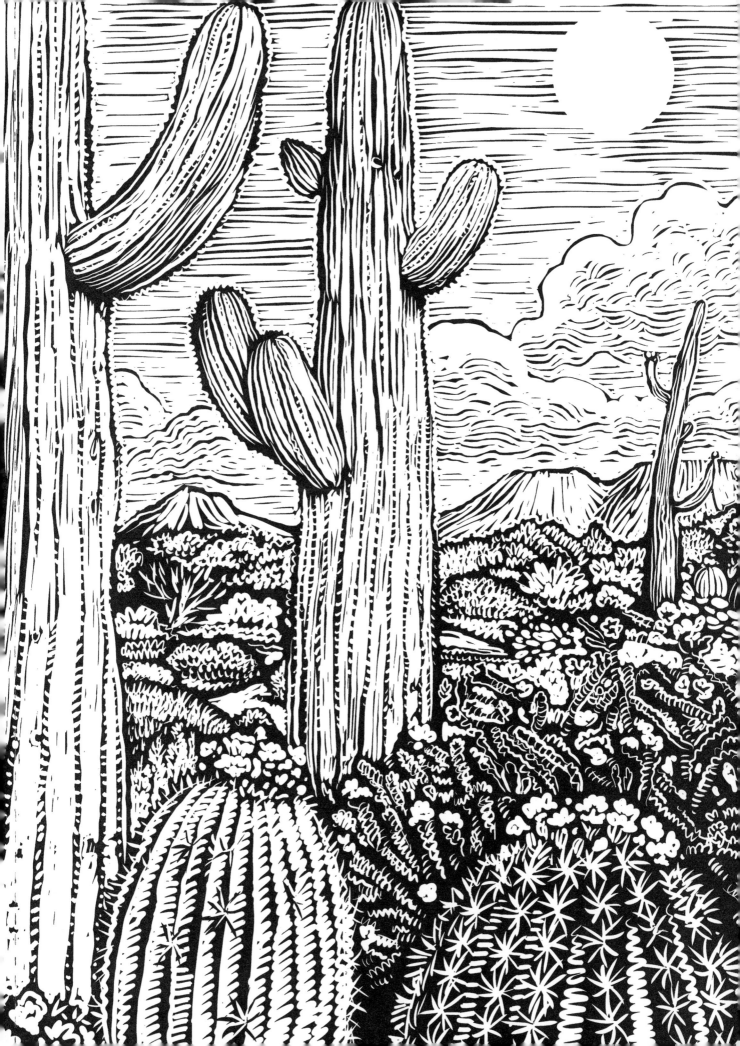

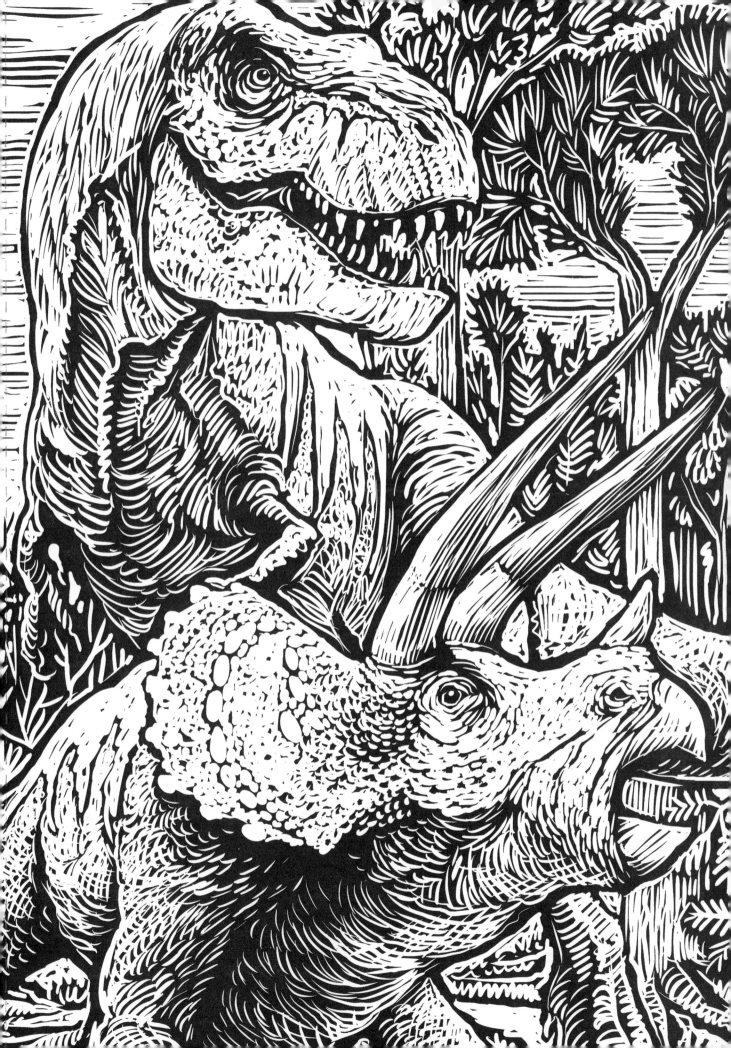

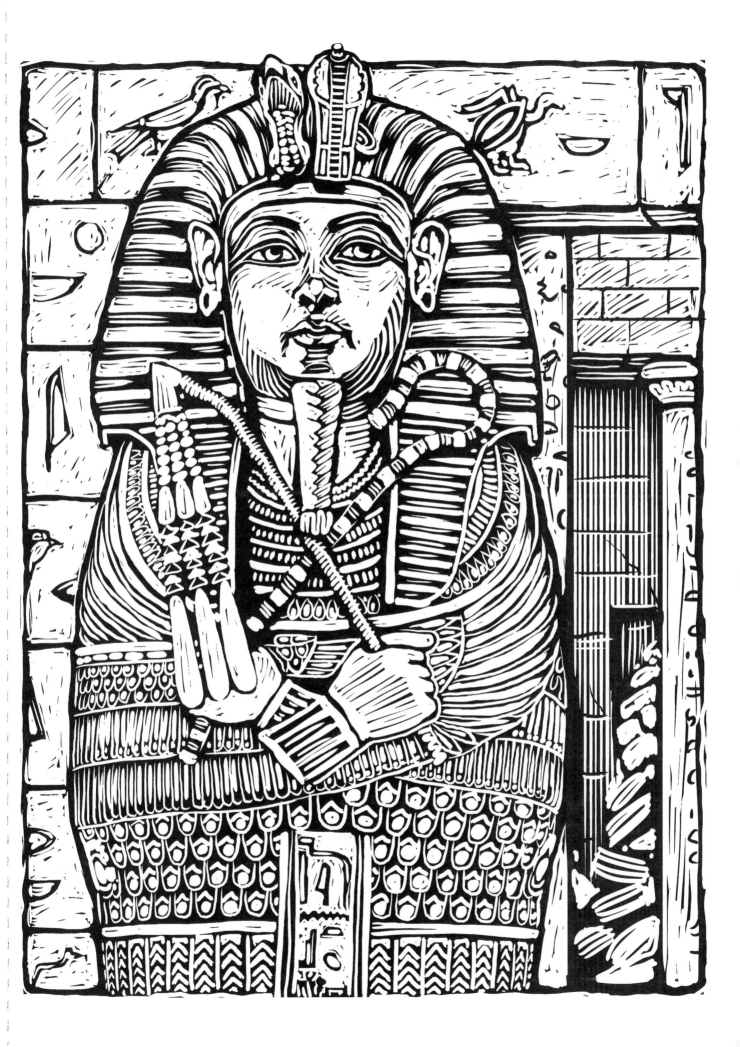